Portland Place

The London Headquarters of the Royal Institute of British Architects

Margaret Richardson

RIBA Publications Limited

To Jill Thomson
who first came to the RIBA in 1956 and, as House Manager from
October 1965 to 1983, has watched so carefully over the RIBA
Building.

66 Portland Place is published to commemorate the 150th year of
the RIBA and also the 50th anniversary of the opening of the
building.

Front cover
The RIBA Building.
The front elevation showing the giant central window surmounted by the
figure of 'Architectural Aspiration' and flanked by the twin pylons bearing
figures of Man and Woman as the creative forces in architecture.

Inside front cover
One side of the Florence Hall showing the carved piers of Perrycot stone
and the bronze torchères.

Back cover
The walnut sliding doors leading into the Reception Room and the first floor
landing.

Inside back cover
Gold 'lap' decoration depicting the tools used on the building, on the
staircase leading up to the second floor.

RIBA badge
The version shown on the title (page 1) is Eric Gill's design for the cover of
the RIBA Journal in 1931. The design on the back cover was prepared by
Joan Hassall and has been in use since 1960.

Copyright © Margaret Richardson 1984

Designed by Gordon Burrows, Philip Handley, and Michael Stribbling

Published by RIBA Publications Limited,
Finsbury Mission, Moreland Street, London EC1V 8VB

ISBN 0 900630 90 6

Typeset by Apex Computersetting Ltd, London EC1
in Linotron Gill Sans

Printed in Great Britain by Battley Brothers Ltd, London SW4

Contents

Historical background

'I do not want to criticize the other designs at all, for I feel sure
that the winning design possesses a far more imaginative layout
and, when completed, will give the effect to visitors that English
architects must be making millions'. Philip Tilden in the *Architects'
Journal*, 25 May 1932.

**The building at Portland
Place**

The present headquarters of the Royal Institute of British
Architects, which was opened on 8 November 1934 by King
George V and Queen Mary, was designed by George Grey
Wornum CBE, FRIBA (1888-1957), who won the commission in an
open competition that attracted 284 entries. In 1970 the building
was listed by the Minister of Housing and Local Government as a
Grade II building of architectural and historic importance, one of
the first fifty buildings of the Inter-War period to be so
recognized.

It is a classic example of an early thirties building, commissioned
by architects for architects, and was at the time a perfect
compromise between classicism and the prevailing modernism. It
was considered 'gentlemanly' but a 'gentleman dressed in clothes
that were not bought in England' (Philip Tilden, *op.cit.*); it had
'modernity with manners' or, as some termed it then, 'Swedish
grace'. The symmetrical simplicity of its exterior was derived
from the Scandinavian Neo-Classicism of Gunnar Asplund's City
Library, Stockholm (1920-8) (Fig. 1), whereas it showed its
modernism most clearly in its section and in the complete
openness of its interior (Fig. 2). Today the symbolism of the
applied decoration and sculpture is once again acceptable, and the
fine quality of building materials and craftsmanship make it both a
period piece and an object worthy of detailed study.

1
Gunnar Asplund.
City Library, Stockholm, 1920-8.

Previous premises

The Institute had moved its quarters three times between 1834
and 1860 but by that date was established at 9 Conduit Street, an
elegant London town house designed by James Wyatt. Here the
RIBA had the settled air of a London club, with its great paintings
by Gandy and portraits and drawings lining the walls of its rooms
and corridors. By the late twenties there was a shortage of space.
The accommodation reserved for the library on the first floor was
inadequate and the floors were not designed to take a heavy load
of books. There was also danger from fire, as at that time the only
heating was by open coal fires. The Conduit Street area had
changed in character, becoming commercialized, and the site was
seen by Council as no longer being a suitable one for the
headquarters of a 'learned and artistic body with a world-famous
library'. It was essential to move elsewhere, and a number of
different solutions were considered.

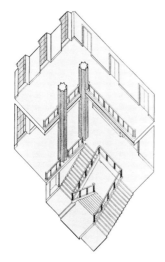

2
G. Grey Wornum.
Axonometric section showing
the interior of the RIBA Building,
1934.

First was the possibility of a new building on the site of
28-36 Bedford Square for both the RIBA and the Architectural
Association; secondly, a site just north of the British Museum (now
occupied by the University of London); but the favourite was the
chance of converting the building in Burlington Gardens by Sir
James Pennethorne, which is now the Museum of Mankind and was
occupied at the time by the Civil Service Commission. It was felt
that it would make a dignified and central home for the RIBA,
being close to the Royal Academy and other learned societies, for
the Institute saw itself in the twenties as the 'Royal and Chartered
body which controls the greatest of the Arts and is the centre of
the architectural education system of the Empire' (Premises
Committee Minutes, 1923-30). After prolonged negotiations,
however, HM Office of Works were unwilling to surrender the
building, and in February 1928, the Institute was free to consider
moving to a new site and designing a new building. Many different
sites were examined, but on 31 January 1929 the forty-eighth
was considered by the Premises Committee, a corner site
62-8 Portland Place and 14-20 Weymouth Street.

By 13 March 1929, negotiations with the Howard de Walden
Estate had been completed for the acquisition of a 999 years lease
for the site. By June that year, the Premises Committee
recommended to Council that an open competition should be
held, in one stage without an eliminating round, and that it should
be open to every member and student of the Institute in Great
Britain and overseas.

The competition

The conditions for the competition were issued in April 1931. The
architectural profession had been severely hurt by the recession
which accounted for the popularity of the 'great' competitions:
Shakespeare Memorial Theatre, Stratford-upon-Avon, won by
Elizabeth Scott in 1929; Guildford Cathedral won by Edward
Maufe in 1931 in Swedish-Georgian style; and Norwich Town Hall
won by S. Rowland Pierce and C. H. James in a pure Swedish style
in 1932.

The assessors were Robert Atkinson (Principal at the AA from
1913-20, then Director of Education until 1932 who promoted the
Beaux-Arts and American architecture, also colour and Art Deco
detailing); Charles Holden (London Transport Headquarters
1928, and Senate House, University of London); Sir Giles Gilbert
Scott (University Library, Cambridge); H. V. Lancaster and
Dr Percy S. Worthington.

The accommodation required was for a Meeting Room to seat
400; a Council Room to seat 60; exhibition galleries also to be

5

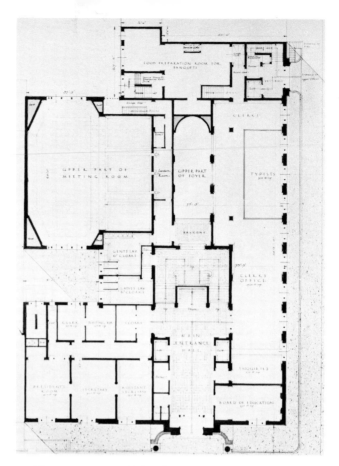

3
G. Grey Wornum.
Winning competition design,
May 1932: the ground floor plan.

used for an examination hall or Banqueting Room to seat 400; a
library; committee rooms and RIBA offices. There was also to be a
large area to be let as commercial offices with a separate entrance;
to be executed at a cost not exceeding three shillings per cubic
foot; the elevations to be dressed in Portland Stone. It was stated
that: 'It should be borne in mind that the new RIBA building, by
reason of its representative character, is likely to be held by the
present and by future generations of architects and the general
public to be an example of the best work of our time. No
restrictions will be placed on the competitors as to style, but the
assessors will seek primarily for evidence of imaginative handling
of plan, structure and material, and for a due sense, in the external
and internal aspects of the building, of the dignity and significance
to the national life of the profession of architecture' (Conditions
for Competition for new premises for the Royal Institute of
British Architects 1931). The hand-in date was 31 March 1932,
and no perspectives were allowed.

Naturally, by early 1932 the profession was agog. An RIBA circular
noted: 'The professional critics will have the chance of their lives
and the war between modernist and traditionalist may be
expected to burst into unequalled fury whatever the result may

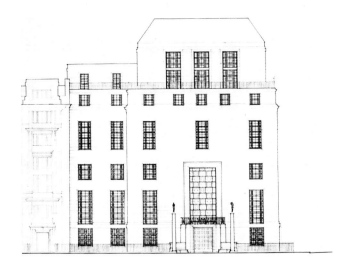

4
G. Grey Wornum.
Winning competition design,
May 1932: the front elevation,
occupying 62-8 Portland Place;
the top three storeys to contain
lettable offices.

be' (March 1932). In April, a worried C. F. A. Voysey (not a competitor) wrote to *The Times*: 'Surely the building we are now considering is quite unique. Will it not be viewed by thousands of laymen, who will never desire to enter the building, but still regard its outside as a true record of the architectural taste of the day? Is it, then, too much to hope that the new building will not so much reflect the material mannerisms of the Greeks and Romans, but rather follow their philosophy and so give to the world a building with purely native character? Considering that, in this case, the outward forms we call the elevations are more important than their plans, the character of a nation is then the spiritual and unseen quality we wish to see expressed, freely and sincerely without any foreign accent'. *The Builder* (29 April 1932) was also worried, and pondered on the difficulty of attaining a 'big idea' as a solution because of the many different problems the competition had set to be solved – notably the difficulty of accommodating two self-contained portions, one the RIBA premises and the other a group of lettable offices.

The winning design

In early May the winner, G. Grey Wornum (Figs. 3 to 6), was announced and the 3,600 competition designs from 284 entrants were placed on exhibition at Thames House, Millbank.

The second premiated design was by Verner O. Rees (Fig. 7), the third by Brian O'Rorke and Kenneth Peacock (Fig. 8), Percy Thomas and Ernest Prestwich (Fig. 9), and Frank Roscoe and Duncan Wylson (Fig. 10). Commended were designs by R. Furneaux Jordan; Horace L. Massey; E. A. A. Rowse, with Jeffreys and Carnegie; Vine and Vine; Richardson and Gill (Fig. 11); L. H. Bucknell, E. W. Armstrong and Miss M. R. F. Ellis; and Scarlett and Ashworth.

Architectural criticism of the designs

It was then that the architectural critics had their field-day and all responded, except the *Architectural Review*, which declined to give any coverage to the competition beyond a few mocking

7

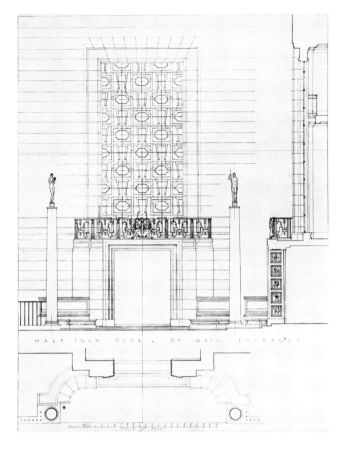

5
G. Grey Wornum.
Half-inch detail of the main
entrance of the winning design.

HALF INCH DETAIL OF MAIN ENTRANCE

6
G. Grey Wornum.
Perspective of the competition
design made later by
J. D. M. Harvey.

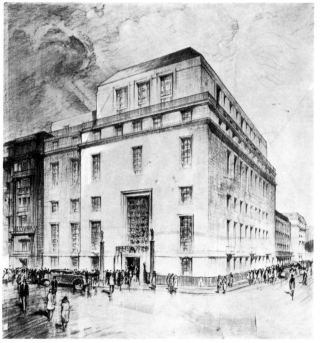

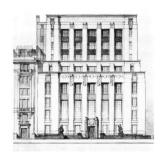

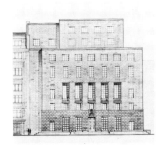

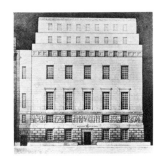

7
Verner O. Rees.
The design placed second.
The fact that the steel frame was so frankly expressed on the elevation was seen as an honest statement by some, while others disliked the design's commercial associations.

8
Brian O'Rorke and Kenneth Peacock.
One of the designs placed third. 'The façade is that of a house: one must obviously ring the front door bell and present a card before being admitted to the – well, ought it to be only the "Periodical Room"? – which alone appears on the front to be expecting visitors' (Goodhart-Rendel in *Architect and Building News*, 24 June 1932, p.418).

9
Percy Thomas and Ernest Prestwich.
One of the designs placed third. 'Style hangs thickly round the lower storeys, and evaporates into air as the building grows upwards' (Goodhart-Rendel in *Architect and Building News*, 24 June 1932, p.418).

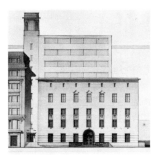

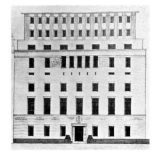

10
Frank Roscoe and Duncan Wylson.
One of the designs placed third. The institutional portion for the RIBA, facing Portland Place, is in Swedish style whereas the lettable offices behind are straightforwardly functional: the best of two worlds.

11
Albert Richardson and C. Lovat Gill.
One of the commended designs, and one that most of the critics at the time preferred to Wornum's. The plan however, had drawbacks. Goodhart-Rendel called it 'aristocratically Institute-like' (*Architect and Building News*, 24 June 1932, p.418).

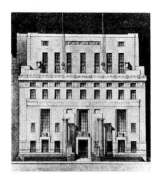

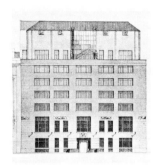

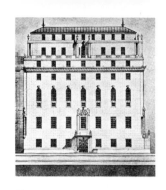

12
John Keppie and Henderson.
Competition design, unplaced. 'Its
Doric columns, used as sentinels,
take us back to L'Ecole des Beaux-
Arts' (Professor S. D. Adshead in
Architects' Journal, 18 May 1932,
p.654), and Goodhart-Rendel
thought it by far the best and
most accomplished elevation
submitted by anybody (Architect
and Building News, 24 June 1932,
p.418).

13
P. J. B. Harland.
Competition design, unplaced.
Another modern scheme, but
supposed by some to be a block
of studios.

14
W. Curtis Green.
Competition design, unplaced.
'A beautifully drawn design; with
its ivory surface and lovely
cornice it suggests Venice'
(Professor S. D. Adshead in the
Architects' Journal, 18 May 1932,
p.654).

quotes of 'Some Opinions' taken from the Architects' Journal. It
repented in 1934, giving over the whole of its December issue to
the RIBA Building, with a refined and fullsome tribute by C. H.
Reilly. The most consistent, witty and best considered judgements
came from H. S. Goodhart-Rendel, writing alternately in the
Architects' Journal and Architect and Building News. In the Architects'
Journal 4 May 1932 he wrote: 'The first impression it must make on
all critical minds, however, is one of hesitation and gaucherie,
combined with nervous self-assertion. British architecture is
plainly suffering from an inferiority complex. A succeeding
impression is more comfortable: if there is little first-rate skill,
there is even less second-rate slickness. There are in the
exhibition several designs for an Institute of Swedish Architects,
a clever design for an Institute of Genoese Architects, some
interesting designs for warehouses and a large sprinkling of
designs for American luxury hotels. Whatever may be our national
sense of humour, so patent to us and so incognizable to other
nations, it cannot arise from any intuition of the inappropriate.
Even among the premiated and the commended designs there are
sad specimens of aesthetic unsuitability. The competition has, I
think, served its purpose in securing for the RIBA an excellent
design, capable of further improvement, no doubt, but, even in its
present form, much better than could have been secured by any
other means'.

Definition of the general characteristics of the competition
designs is difficult as only about a third of the 284 entries survive,
the majority reproduced in architectural journals. Only five
(including all Wornum's competition designs and working
drawings) are in the RIBA Drawings Collection. But from what

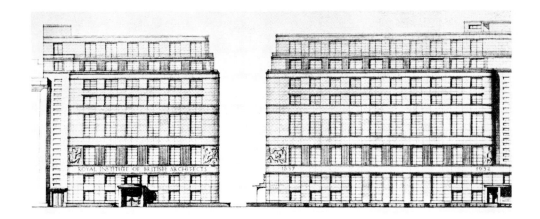

survives it appears that the majority were in the 'stripped-classical' style, made so popular by Sir John Burnet's Adelaide House of 1924 and by Val Myer's BBC Building further down Portland Place. They were modern in the sense that they 'expressed' different floor levels and were plain, but also had the moderate window patterning of a Georgian façade. In this group were the designs by O'Rorke and Peacock (Fig. 8) and by Richardson and Gill (Fig. 11), the latter being the favourite of most critics in the architectural press.

Surprisingly, only a very few were fully-fledged classical designs in the Grand Manner, using the orders. Sir Guy Dawber's was one of the best; Goodhart-Rendel preferred the Beaux Arts elevation by Keppie and Henderson (Fig. 12) and Max Fry admired 'the fine sturdy design' by Percy Thomas and Ernest Prestwich (Fig. 9). Again, only a handful, four or five, were progressive and 'Modern' in the sense of the Modern Movement. Max Fry's (Fig. 15) was considered the best of these and Sir John Summerson remembers him as being the only competitor 'who did the brave thing and stuck to his Modernist guns.' P. J. B. Harland's design was probably cleverer but was unplaced and unnoticed, except by Goodhart-Rendel (Fig. 13). Verner Rees's design (Fig. 7), in second place, was much admired for its honest elevation and frank expression of structure and was one of the few to express its steel frame. It was Max Fry's favourite at the time.

Some designs were idiosyncratic. W. Curtis Green's (Fig. 14) was beautifully drawn, with delicate Venetian details, and should have won a prize for architectural elegance, and Joass and E. A. Rowse both provided Portland Place with towers. One would love to have seen William Walcot's entry, or Arnold Mitchell's, or Hume and Erith's or Mewès and Davis's, but these were not illustrated in the architectural press, and we only have Professor S. D. Ashead's description to go by: (*Architects' Journal*, 18 May 1932): 'William Walcot sends a set of drawings which include an elevation in the real Roman manner, marvellously drawn and beautifully suggestive of Roman detail . . . Arnold Mitchell's which encloses the Institute

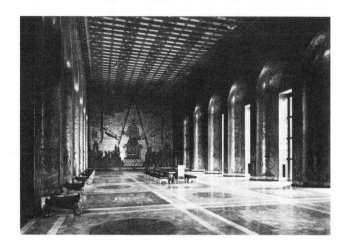

16
The Gold Room in Ragnar
Östberg's Stockholm Town Hall.

in a Doric temple . . . if, instead of an Architects' Institute it was a Greek archaeological musuem it would be an excellent scheme.'

In general, although many felt that Grey Wornum's competition elevation was unconvincing in its fenestration or too blatant and out of character with Portland Place, most were agreed that his design deserved to win for its plan and, above all, for its section. He had solved the great problem of conveying five hundred people either to the Meeting Room or to the Exhibition Gallery without corridors and without the use of lifts. In Max Fry's opinion the outstanding merit in the design was in the 'imaginative handling of the staircase levels which command views both upward and downward of great richness and complexity' – an opinion that was fully confirmed when the building was executed.

One of the repeated sentiments in all the many reviews throughout May 1932 was that although the assessors may not have chosen the right scheme, they had chosen the right man for the job. The assessors had made this very clear in their statement of 28 April 1932: 'We have found no design that we think suitable for execution exactly as submitted and have, therefore, made our decision with a view to the selection of the author whom we regard as best qualified to satisfy the New Premises Committee in providing the building most suitable to the architectural and practical requirements of the RIBA' (New Premises Committee Minutes, 1930-4).

George Grey Wornum was good-natured and charming, elegant and tactful, and a modernist of the non-progressive kind. From 1914-18 he had served with the Artists' Rifles and in the Durham Light Infantry. He was badly wounded on the Somme and lost his right eye. After the war he was in partnership with Philip Hepworth and, later in the twenties with Louis de Soissons. His American wife, Miriam Wornum, was an artist and interior designer and collaborated with him on many schemes, particularly the RIBA Building. Wornum's friends and contemporaries were all Architectural Association people – Hepworth, H. Chalton

Bradshaw, Edward Maufe and de Soissons, and Wornum himself was on the AA Council and its President from 1930-1.

Grey Wornum had led the AA excursion to Stockholm in 1930 and Charles Reilly wrote that 'he must, I think, have been inspired in his methods of setting about his big job by Ragnar Östberg, the famous architect of the Stockholm Town Hall' (*Scaffolding in the Sky*, 1938). Reilly and Wornum met Östberg on that trip, and it is interesting that in 1959 Mrs Wornum presented the RIBA with the original cartoon by Einar Forseth for the mosaic in the Gold Room at Stockholm Town Hall (Fig. 16).

The revised designs

But in the hard world of reality, on 30 June 1932, the RIBA's New Building Committee was already cutting costs. Wornum was asked to prepare sketch plans omitting the accommodation which was to be available for letting as offices and also the portion to be built on the site of 68 Portland Place. The Finance Committee could only allocate £125,000 to include furniture and fittings and all the fees. The structure should be able to carry extensions. On 13 July he submitted his revised sketch plans for a scheme to cost £130,000. On 26 July he was asked to bring his total sum down to £100,000, and during that summer worked on revising the design, following suggestions made by Sir Giles Scott. Wornum sent Scott a postcard from Guethary in southern France dated 28 August 1932: 'I have just been into Spain and send you 3 cards of altars from San Gil, Burgos. I have found your proposals for the RIBA most helpful and am bringing back a scheme embodying a great deal of them . . .' (Sir Giles Scott papers, RIBA Library). There are sketch plans similar to Wornum's scheme among Scott's drawings in the RIBA Drawings Collection (Sir Giles Scott [105], Scott Family Catalogue). Only on 3 October 1932 was he formally asked to go ahead with the working drawings for a building to cost £102,972.

By now the revised design (Figs. 17,18) was very different from the winning one, occupying only the site of 62-6 Portland Place. It was a symmetrical design without the top three floors of offices, which must have pleased Goodhart-Rendel, who had disliked 'that building's taste in hats' (*Architect & Building News*, 24 June 1932). There was some criticism in the press that the competition schedule of requirements had not been just limited to an institute but had included offices, and then so shortly afterwards, the offices had been cancelled. So many competitors had failed in trying to incorporate the two.

On 7 April 1933, Grey Wornum's revised designs were unanimously approved by the New Building Committee; by May

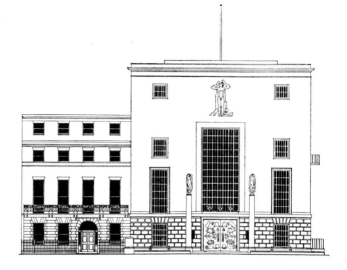

17
G. Grey Wornum.
Revised design, July 1932, as built:
the front elevation.

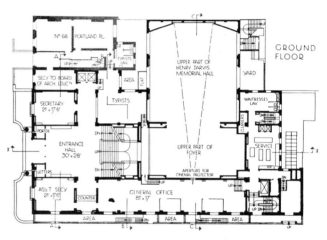

18
G. Grey Wornum.
Revised design, July 1932: the
ground floor plan.

demolition of the old buildings were in progress and the
foundation stone was laid on 28 June by the Rt Hon. Lord Howard
de Walden. Ashby and Horner's tender for £106,250 was accepted
on 18 July. On 15 November two steel girders to go over the
Banqueting Hall, measuring 61 feet long by 12 feet deep, were
brought from the Albert Docks and blocked traffic in Portland
Place for some hours.

The artists and craftsmen

In his 1932 Competition Report, Wornum had defined his
intentions relating to ornament and craft: 'The interior effects
would be enhanced by rich examples of English craftsmanship in
all materials and would constitute rather surface decoration than
elaborate form'. By December 1932, with his building costs cut by
half, Wornum clung to his ideals but admitted that 'with the
present money available the full decoration of the building could
not in any way be completed' (*Builder*, 9 December 1932). Later
the New Building Fund raised a considerable sum from architects,

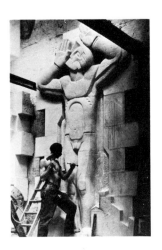

19
Contemporary photograph
of the figure of 'Architectural
Aspiration' being sculpted by
Bainbridge Copnall, 1934.

WITHDRAWN-UNL

and Wornum himself donated the Woodford figures of Man and
Woman on pylons at the front. It could, therefore, have been for
reasons of economy that Wornum turned to a young and unknown
group of artists and sculptors to work on the building. At the end
of 1932 he installed the sculptor Bainbridge Copnall on the ground
floor and basement of 68 Portland Place, where he could live and
work free of rent with a salary of £5 per week, plus a bonus on
completion. Number 68 became the home and studio for the
craftsmen on site (Fig. 19). Charles Reilly described it vividly:
'Grey Wornum and his artist wife, like Östberg and his, gathered a
group of sculptors, glass engravers and craftsmen of all kinds, as
well as draughtsmen, to work together practically on the site.
Fortunately the RIBA owned the building next door and here he
housed them all, some for the day only, some for the nights as well.
I went to one or two of the jolly daily luncheons there with Grey
at one end of the table and Miriam, his wife, at the other and all his
merry company of workers, I would say disciples if he were not
still so young, having a good time and a good meal combined.
Work done under such happy conditions, so like those one
imagines of the Renaissance, should show some of the same
spontaneity.' (*Scaffolding in the Sky*, 1938).

For Copnall, James Woodford and Jan Juta, the glass engraver, the
work was an important early commission in their careers, and
both Copnall and Juta went on to work with Wornum on the
interiors of the RMS 'Queen Elizabeth' later in the thirties. There
was, however, a feeling at the time that the artists employed on
the building were not quite good enough for Copnall was not an
Eric Gill or Kennington, and in June 1933 the New Building
Committee did suggest that the sculptor C. S. Jagger should be
asked to design the figures at the main entrance. Wornum,
however, was loyal to his team of artists and skilfully protected
both Copnall and Woodford from criticisms made by Colonel
Blount of the Howard de Walden Estate Office.

The sculpture and decoration of the RIBA building made it
an amazing casket of contemporary art, an English version of
Stockholm Town Hall. So many of the mannerisms were Swedish,
the walnut veneer, engraved glass, library shelves and lighting and
stars on the floor, but the iconography created referred to English
architecture and did very well in dressing the building as an
Institute of Architects.

The idea of using applied decoration to build up the symbolism of a
building was much used at the time. The BBC building in Portland
Place, completed in the early thirties, has exterior groups of
sculpture by Eric Gill, whose subject was Shakespeare's *Ariel*,

15

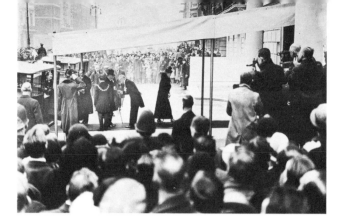

20
Contemporary photograph of
H.M. King George V and Queen
Mary arriving at 12 noon for
the opening ceremony on
8 November 1934.

symbolising the 'invisible spirit of the air'. The Shakespeare
Memorial Theatre at Stratford by Elizabeth Scott completed in
1932 and in some ways a very comparable building to the RIBA,
symbolised the iconography of theatre with sculpture and
decoration by Eric Kennington. India House by Herbert Baker,
has Asoka columns skyed on corbels carrying the lintel over the
entrance, Indian symbols of Empire.

**Completion of the new
building**

The building was finished by November 1934, marking the
100th anniversary of the Institute's foundation and opened by
their Majesties King George V and Queen Mary on 8 November
(Fig. 20). Sir Giles Scott, President RIBA, gave the address,
recalling tradition but looking forward to progressiveness. The
building seemed to have fulfilled the Institute's brief; it provided
room for the Institute to expand its activities and extend its image
into modernity. This the Institute did proceed to do in the thirties
particularly with a brilliant series of exhibitions, notably
'International Architecture' in 1934 (Fig. 21) and 'Everyday Things'
in 1936.

During the fifties and sixties, the RIBA Building was not always
appreciated. It was listed Grade II in 1970, although the news took
the RIBA Council by surprise and caused general hilarity. Alison
Smithson told the *Evening Standard* that the building was lousy and
should be dynamited, and in May 1970 a letter to the *RIBA Journal*
summed up a feeling possibly widely held then by the profession:
'As long as the RIBA stays behind that façade in Portland Place it
must inevitably be associated with the pretentiousness of archaic
symbolism!'

It is possible that it was only in the late seventies with the rise of
eclectism, that the RIBA Building could be correctly assessed,
probably for the first time. Symbolism is now once again
acceptable; the applied decoration and sculpture can be judged in
its period context. The wide range of building materials; the
Perrycot stone in the Florence Hall, Ashburton marble columns
on the stairs, bronze, blue enamelled steel in the library, walnut,
greywood, pine, all radiate sheer quality.

21
Contemporary photograph of
'International Architecture 1924-
34', the first exhibition to be held
in the Florence Hall in 1934.

We have now a greater understanding of the building's dual
nature. It had Swedish grace and the then current Scandinavian
preoccupation with the Neo-Classical, expressed on the exterior
in the massive 'stylistic' central window, economical fenestration
and bare walls. The interior had its own modernity in the
ingenious way Grey Wornum slotted together the various cubic
spaces and achieved transparency. It was the first building without
corridors in London, a reputation it held until David Du R.
Aberdeen's Trades Union Congress Building of 1948.

In 1934 the RIBA Building had its supporters and detractors. The
influential Robert Byron despaired of Wornum's 'hotchpotch of
plagiarisms' (Architects' Journal, 1 June 1932), and both Max Fry
and William Crabtree felt that the elevation did not express its
function. A. Trystan Edwards however, believed that the building
did express its function in the element of symbolism it offered. In
retrospect, Sir John Summerson has said that it was not quite the
real thing, but a move in the right direction, but it was not on the
new platform of modernism. On the other hand no-one laughed
at it. A. S. Gray however, who was a Lutyens devotee, has said that
he found it much too bold and modern with its great window and
columns interrupting the Adam elegance of Portland Place.

In the conservationist climate of the early eighties, when the
façade of the Chinese Embassy opposite the RIBA Building is to be
rebuilt to copy its original form, it may seem remarkable that
permission was ever given for Wornum's design. The case
however, was well put by Sir Giles Scott, President in 1934 and
principal assessor, who said that 'they had adopted the only
possible solution by building with extreme simplicity, so that if
others would follow, they would get another and different
uniformity – that of simplicity and austerity.'

Exterior

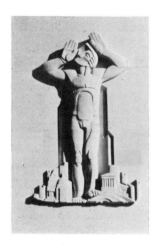

22
The figure of 'Architectural Aspiration' by Bainbridge Copnall.

The main façade of the RIBA Building forms an austere and symmetrical rectangle of Portland stone, dominated by the giant central window above the bronze entrance doors (front cover).

There was considerable debate and criticism amongst architects about this window in 1934, particularly of the way the second floor girder breaks across the front elevation. Some, like William Crabtree, felt it to be dishonest – as if Wornum had a floor to deal with but wanted his giant window as well. Others, and notably A. Trystan Edwards, did feel that the building honestly expressed its function by pointing out that the window hinted at the transparency of the interior and matched the great inner window of the Florence Hall. Charles Reilly said that without it no one would guess that there were 'great halls' within. The façade did, moreover, with its references to Scandinavian Neo-Classicism, give the Institute the stylish and appropriate uniform of a learned and professional society, an assessment that carried the day.

The sculptures on the main façade were also subjected to a certain amount of criticism. The giant window is surmounted by the sculpted relief figure of Architectural Aspiration by Bainbridge Copnall (Fig. 22), and flanked by figures on columns by James Woodford depicting Man and Woman as the creative forces of architecture. Colonel Blount of the Howard de Walden estate office watched their execution with discreetly controlled dismay. He had seen the drawings submitted for his approval in early 1934, and the clay inch-scale model of the building, but watched with alarm as the sculptures were finished off *in situ* and asked to have them removed. Wornum skilfully countered by asking him to define his criticisms and invited him to Woodford's studio. Blount thanked him but said that he did not think 'it would serve any good purpose because I am quite incompetent to deal with details of sculpture ... I have only a sort of general knowledge as to what is pleasing to the eye and I am bound to say that the figure on the elevation to this building is not pleasing to me personally' (New Premises Minutes, 1932-7). Pevsner, too, in 1952, although he appreciated the RIBA Building as being 'decidedly twentieth century, Scandinavian in ancestry, with a flat roof and no superfluous mouldings', commented on 'the two odd free-standing pillars with aspiring but otherwise obscure statues on top'. Today, we are able to come to terms with the decorative qualities of the sculptures and the symbolism they express.

The relief figures by Bainbridge Copnall along the Weymouth Street elevation were always more successful (Fig. 23). The central one depicts an Architect (Sir Christopher Wren, Fig. 24), flanked by the Painter and Sculptor (with hammer) and, at the ends, by the Artisan (with crossed arms) and Mechanic.

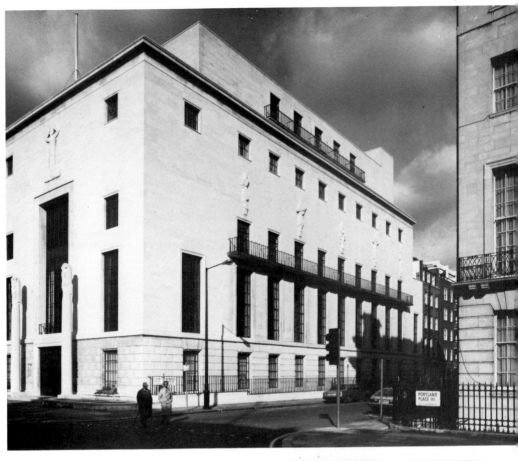

23
The side elevation to Weymouth
Street.

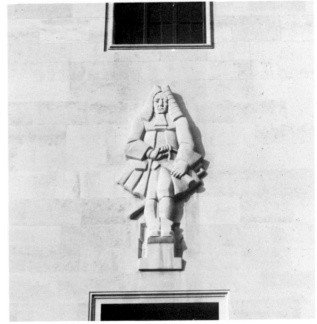

24
The central figure of the Architect
(as Sir Christopher Wren) by
Bainbridge Copnall, on the
Weymouth Street elevation.

Entrance doors

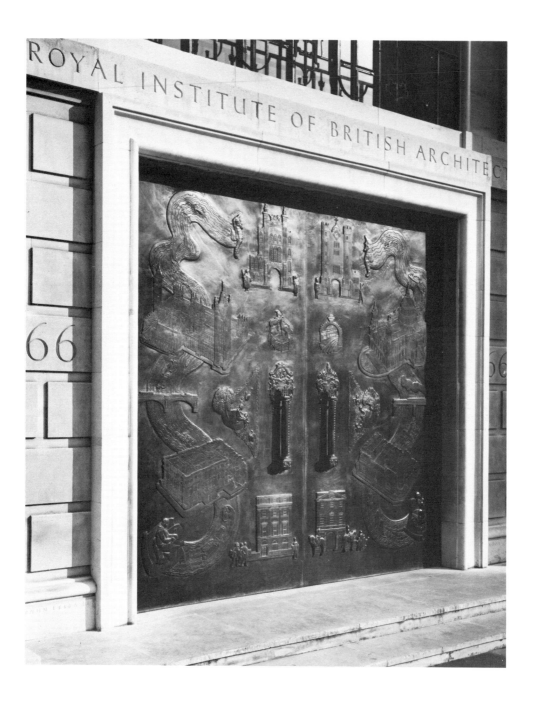

The cast bronze doors, each one measuring 12 feet high by 6 feet wide and weighing 1½ tons, were modelled by James Woodford. The deep relief depicts 'London's river and its buildings' (Fig. 25).

The left-hand door shows the Guildhall (the City of London's House), the Houses of Parliament, the Zoo, the old (Rennie's) Waterloo Bridge, Stafford House (the Rich Man's House) and 9 Conduit Street, the former premises of the RIBA. The right-hand door shows St James's Palace (a Royal House), a tube tunnel (Fig. 26), St Paul's Cathedral (God's House), Charing Cross Railway Bridge, an LCC Tenement (the Poor Man's House), and the Horse Guards (the Soldier's House). The three children swimming in the pool represent Grey Wornum's own children. The door handles carry the arms of the Borough of St Marylebone and of Lord Howard de Walden.

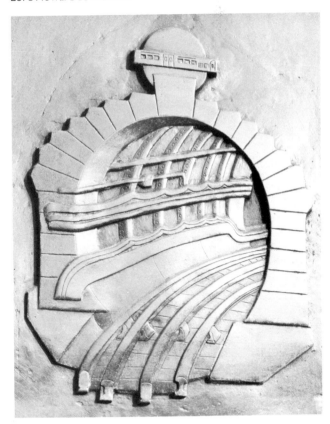

25 (opposite)
The bronze entrance doors by James Woodford.

26 (right)
A detail on the entrance doors: a London Underground tube tunnel.

Entrance hall

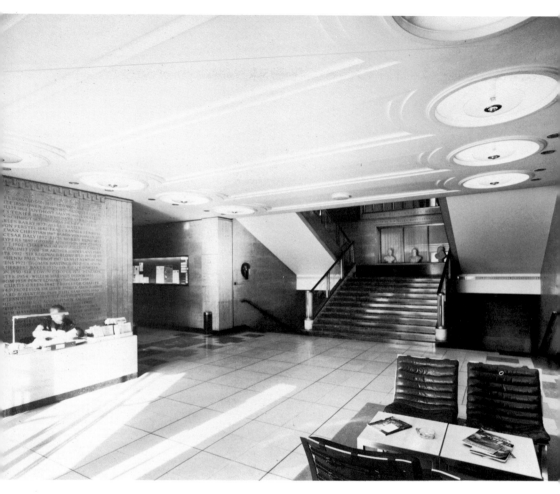

27
The entrance hall.

The inner doors of the entrance have silver bronze frames, although the central revolving door was installed later in 1975. The walls of the hall are lined with polished Perrycot limestone, with the names of the Royal Gold Medallists incised on the left-hand side and of the Past-Presidents on the right above the RIBA Bookshop's display window (a later insertion). The lettering is by Percy Smith (Fig. 27).

The floor is made of pale yellow pre-cast terrazo slabs separated by light bronze strips, with surrounds of Hopton Wood stone and grey Derbyshire marble. Inset in the floor are three panels designed by Bainbridge Copnall which depict the instruments of office routine: the telephone (near the lift), ink well, and

28
One of the panels set in the floor of the entrance hall showing a decorative design of a typewriter, postbox, letters and books.

typewriter, letters and books (near the entrance to the Bookshop, Fig. 28). Note in the latter the initials *MGW* (Miriam and Grey Wornum). The lift gates are of green, cellulosed steel and silver bronze, surmounted by a clock.

Lower ground floor: Henry Jarvis Hall and Foyer

At the head of the left-hand stair flight leading downwards is the bronze bust of the architect George Grey Wornum.

The main stairs lead down into the Foyer, at the end of which is the Foundation stone. The wall space above it was intended to be the spot where the portrait of the immediate past-president should be hung. The RIBA badge and inscription were designed and cut by Ernest Gillick. The carpet, bearing the RIBA badge, was fitted in 1974.

Two doors lead into the Henry Jarvis Hall, a fully equipped lecture theatre, named after a member who bequeathed a sum of money in trust for the use of the Institute (Fig. 29). Between the Hall and

29
The Henry Jarvis Hall.

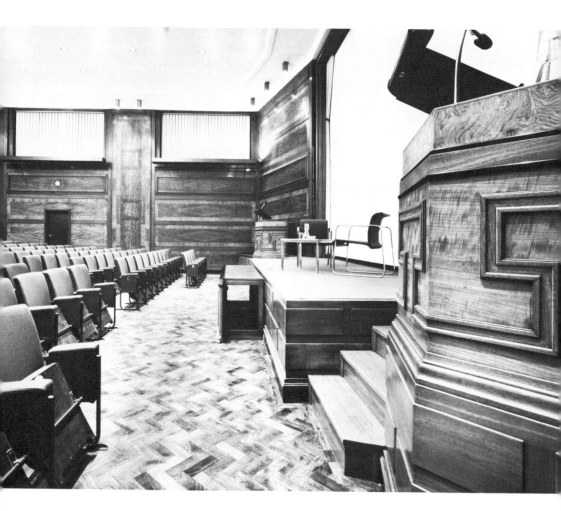

the Foyer is a 'disappearing wall', which is arranged to descend, by counterbalanced hand-winch, into the basement to allow the Foyer to be used as an extension or separate meeting room for smaller functions. On the side of the Henry Jarvis Hall this wall is decorated with a canvas mural by Bainbridge Copnall and Nicholas Harris depicting the 'Empire – wide scope of the RIBA', which shows a symbolic RIBA Council surrounded by the peoples and buildings of the Empire. The panelling and woodwork throughout are of figured teak, olive ash and black bean, and above the doors are acoustic panels by Bainbridge Copnall decorated with formal compositions, one of books and papers and the other of tee-squares and drawing boards (Fig. 30).

30
An acoustic panel in the Jarvis Hall decorated with tee-squares and drawing boards.

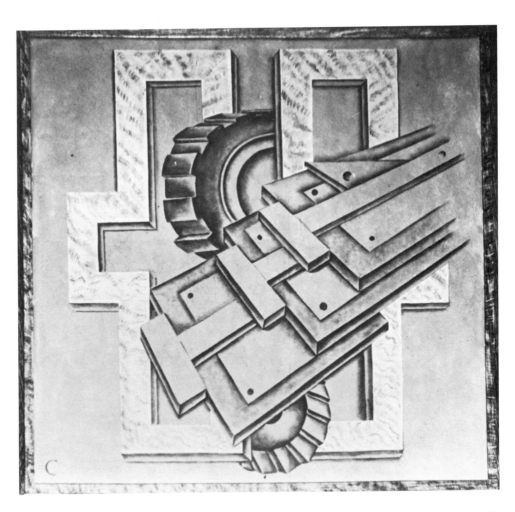

Main staircase

The main staircase, with its gently rising treads and quarter-space landings, is the most beautifully detailed public area in the building (Fig. 31). The treads are of dark-blue Demara (African) marble above risers of black Derbyshire marble and the stairwell linings are of Perrycot stone. The balustrading is of 'Armourplate' glass set in silver-bronze frames with handrails of golden-bronze and ebonized mahogany (Fig. 32). The glass panels are etched by Jan Juta, with abstract designs on the stair itself and with the Royal coat of arms, the coats of arms of the Dominions and the RIBA lions on the balustrade at first floor level. He used polished plate in each feature and combined acid-embossing and brilliant-cutting with silver fired into the glass, to engrave the heraldic devices and lines. The panels are edge-lit by strip lighting to bring out the patterns strongly.

Rising above the stair at first floor level are the four great marble columns, which in their richness and scale, contribute so much to the institutional splendour of the building.

31 (below)
A view up the main staircase from the entrance hall.

32 (opposite)
A detail of the main staircase.

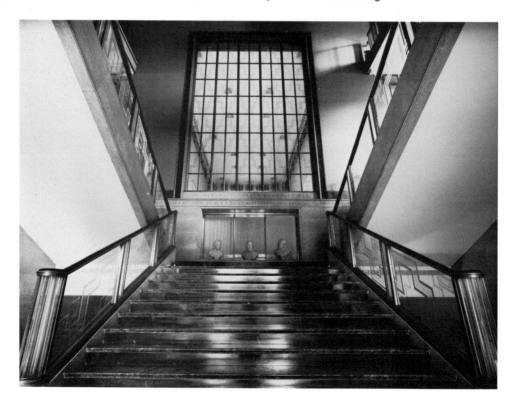

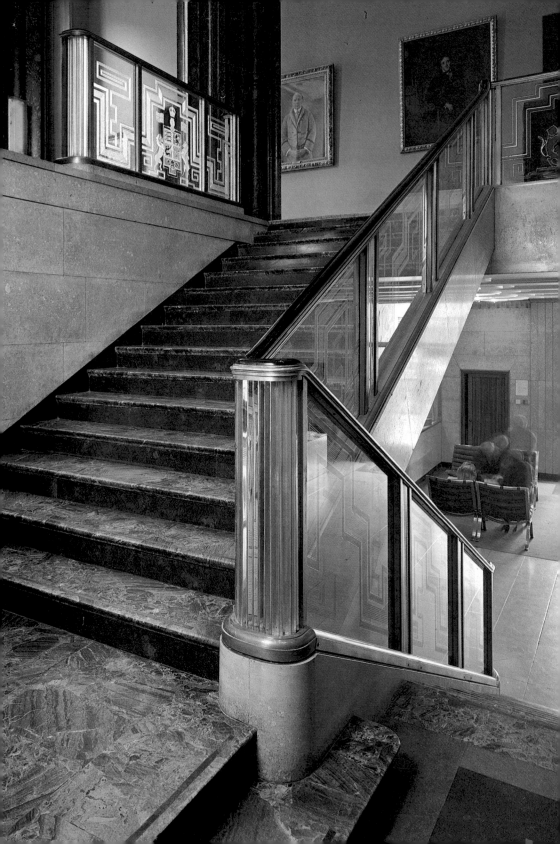

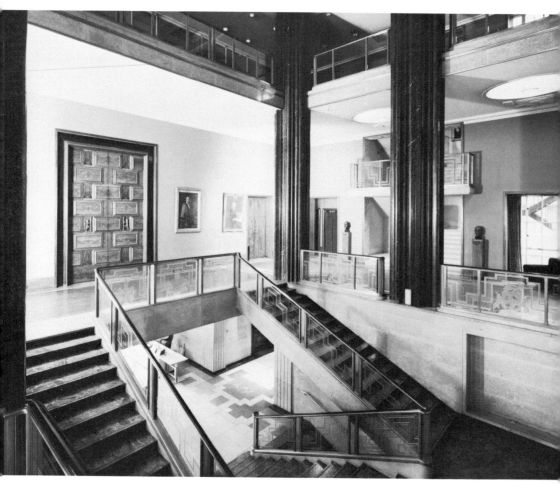

33
The walnut sliding doors leading
into the Reception Room and the
first floor landing.
A detail of this illustration is also
reproduced in colour on the back
cover.

The whole of the first floor forms the principal ceremonial unit of the building and the general effect at this level is one of transparency and spaciousness (Fig. 33).

Facing the stairs are the large, sliding doors made of English walnut with panels of figured Indian laurelwood 'curls'. Two lions in silver bronze from the RIBA badge serve as handles; these are by Seaton White. The doors lead into the *Reception Room*, designed for smaller exhibitions, and specifically to show the Institute's own collection of drawings. The windows of this room very cleverly run up to the ceiling so as to hide the fact that one of them, the great West window on the front elevation, runs up beyond it. Under this window is a panel set in the floor depicting animals and flowers, designed by Bainbridge Copnall.

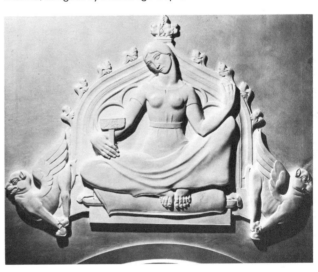

34
One of the plaster panels, set in the ceiling of the first floor, representing 'Perpendicular'.

On the first floor landings are six plaster panels, set in the ceilings, which show the main periods of English architecture. They are by James Woodford. On the Weymouth Street side are 'Early English', 'Decorated' and 'Tudor', and on the North (lift) side are 'Norman', 'Perpendicular' (where the figure was modelled on Wornum's wife, Miriam, Fig. 34) and 'Saxon'.

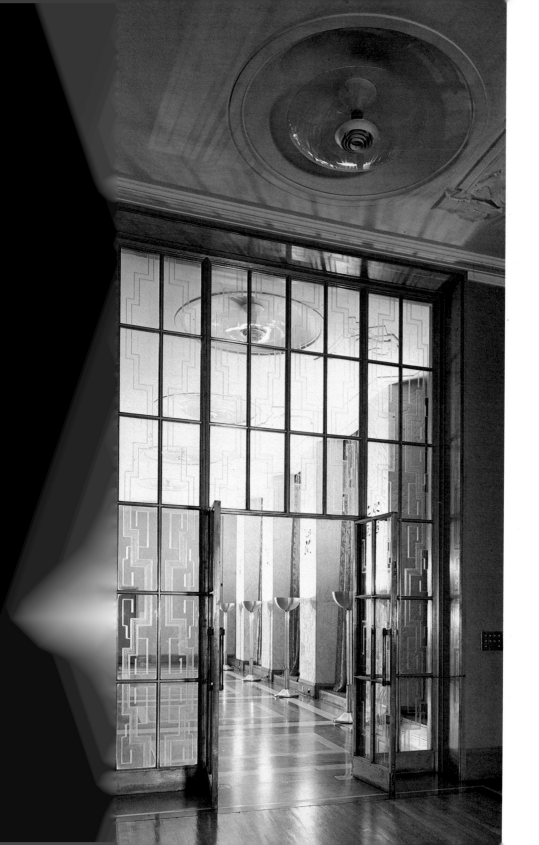

Henry Florence Hall

The Florence Hall was designed as the Institute's principal reception room – to be used for banquets, balls, exhibitions and examinations. It was named after Henry L. Florence, a former Vice-President and architect of Her Majesty's Theatre in the Haymarket, in whose memory H. S. E. Vanderpant gave a large donation to the New Building Fund.

It is this room with its etched glass doors and screen by Jan Juta (Fig. 35), incised stone piers, patterned floors and plaster ceilings that comes closest to the spirit of Östberg's Gold Room in Stockholm Town Hall, a spirit that Wornum and his team of craftsmen closely emulated. Charles Reilly noted that it was here that a member of the Swedish legation commented in 1934, 'England has at last discovered Sweden' (*Architectural Review*, December 1934).

The main feature of the room are the deeply splayed piers of Perrycot stone which are incised with a series of carvings, very Banister Fletcher in spirit, of 'Man and his buildings throughout the ages' (Fig. 36 and Inside front cover). They were executed by stone masons from full-sized cartoons by Bainbridge Copnall. On

35 (opposite)
One of the glass doors, etched by Jan Juta, leading into the Florence Hall.

36 (below)
A view of one side of the Florence Hall at night.

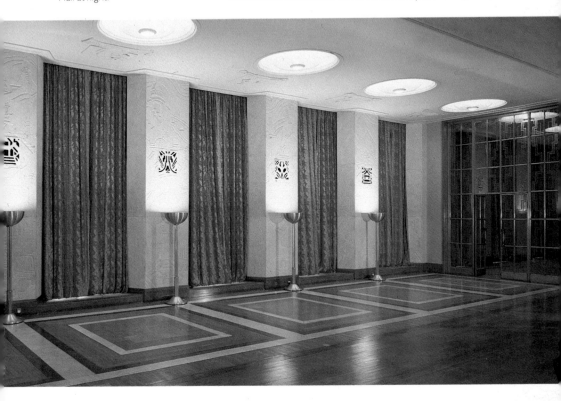

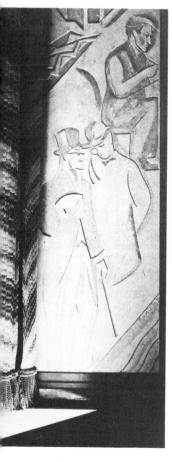

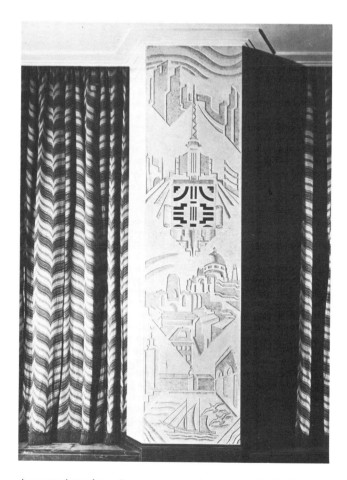

37 (above)
A detail of one of the piers
showing Maurice Webb, Grey
Wornum and Ragnar Ostberg
seated at his drawing board.

38 (above, right)
The front of one of the piers
showing the three great buildings
of the twentieth century:
Sir Giles Scott's Liverpool
Cathedral;
Lutyens's design for the
R.C. Liverpool Cathedral; and
Ostberg's Stockholm Town Hall.

the second pier from the entrance, on the terrace side, is Maurice
Webb (Chairman of the New Building Committee) and Grey
Wornum (with monocle), with Ragnar Östberg seated above at
his drawing board (Fig. 37). On the front of the same pier are, in
the estimation of Wornum and, no doubt, of many others on the
New Building Committee, the three great buildings of the
twentieth century: Sir Giles Scott's Liverpool Cathedral,
Lutyens's unexecuted design for the R.C. Liverpool Cathedral
and Östberg's Stockholm Town Hall (Fig. 38).

The main floor area is made of Indian silver greywood teak, flanked
by patterns of grey and black birdseye marble and white and grey
Hopton wood stone. The lower ceilings on the North and South
sides carry plaster reliefs by James Woodford which represent the
principal trades of the Building Industry. Many contain portraits of
the men who worked on the building. They are, from the door

39
The Dominion screen.

(terrace side), the Electrician (a portrait of James Woodford)
(Fig. 40), the Plumber, the Fitter, Carpenter, and Engraver, and, on
the Weymouth Street side, the Slater, Glass Cutter (a portrait of
Jan Juta, who etched all the glass in the RIBA Building, Fig. 41),
Steel erector, Plasterer and Bricklayer.

Below the large East window is a screen of Quebec pine, carved to
the designs of Dennis Dunlop to represent the peoples, industries,
flora and fauna of the Dominions of Canada, Australia, India, South
Africa and New Zealand (Fig. 39). The silver bronze and glass
torchères were designed by Wornum and date from 1934.

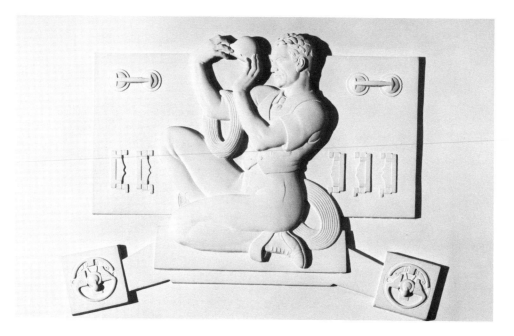

40 (above)
The Electrician (a portrait of
James Woodford); one of the
plaster reliefs on the ceiling of
the Florence Hall.

41 (below)
The Glass Cutter (a portrait of
Jan Juta).

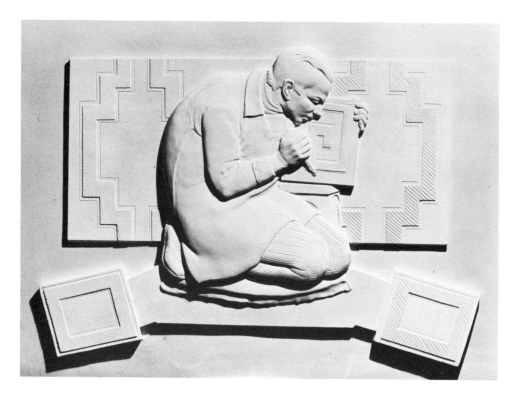

Second floor

A side staircase near the lifts on the first floor leads up to the second floor landing and committee rooms (Fig. 42). The jambs and soffits of this staircase are decorated with cream and gold 'Lap', modelled by Bainbridge Copnall to illustrate the tools used on the building (Inside back cover); the glass balustrade bears the RIBA badge.

It is from the second floor landing that one can best appreciate the great feeling of spaciousness of the interior of the RIBA Building and the dramatic height of the central stair well (Fig. 43). The general effect of the stair and vistas downwards is that the building is immensely bigger inside than one expected from the exterior, and this sense of drama and immensity is no doubt partly contrived by the design of the four massive columns, concrete-clad steel stanchions, each cased with black Ashburton marble and each without bases or capitals, which rise from the first to the ceiling of the second floor, defining the corners of the gallery. The best vistas are of the great etched glass screen and doors of the Florence Hall.

The wide gallery runs past committee rooms (including the Sir Aston Webb Room) to the South Committee Room on the Weymouth Street side, which was originally designed as the Members' Room and Bar.

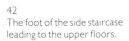

42
The foot of the side staircase leading to the upper floors.

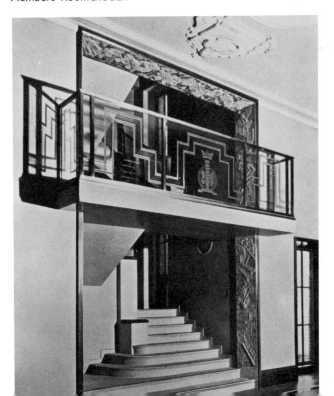

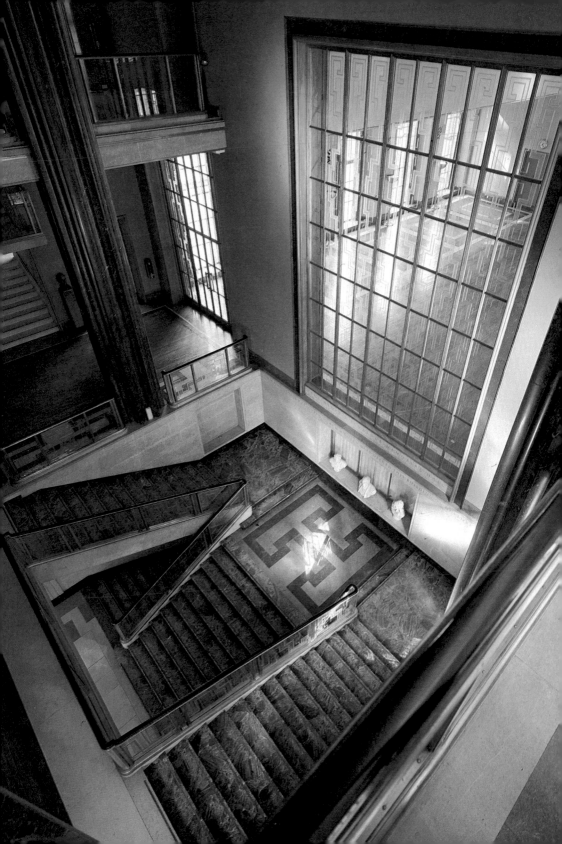

Third floor: British Architectural Library

The RIBA Building competition conditions had stated that the RIBA Library was 'probably the finest architectural library in existence and as such should have an appropriate setting'; overcrowding in the library at Conduit Street and danger from fire had been the prime reason in 1929 for the proposed move. Wornum's design amply fulfilled the brief. He worked with the then librarian, E. J. (Bobby) Carter to evolve its programme, and with his wife to create a colour scheme that was the antithesis of the club-like sombreness of the Wyatt building at Conduit Street (Fig. 44).

The entrance is at third floor level to the information desk and to the Sir Banister Fletcher Reference Library. Closed rolling stacks, which now house the Early Works collection and other rare books and periodicals, and the Loan Library range along the long south wall and also conceal an internal stair leading up to the open Periodicals Gallery. Projecting steel bookshelves, stove enamelled in blue on the outsides and yellow on the insides, project into the main nave of the reference section to form reading alcoves

43 (opposite)
A view of the central stairwell from the second floor.

44 (below)
Miriam Wornum.
Design for the colour decoration of the Library, 1934.

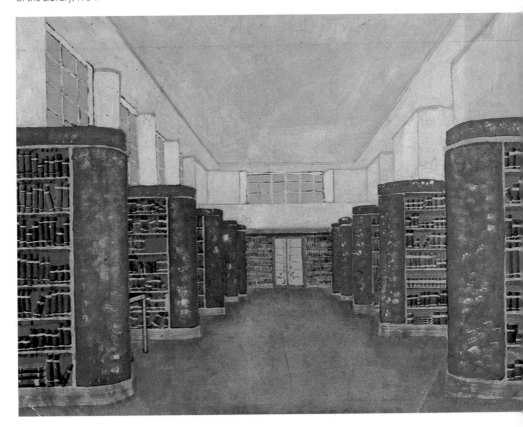

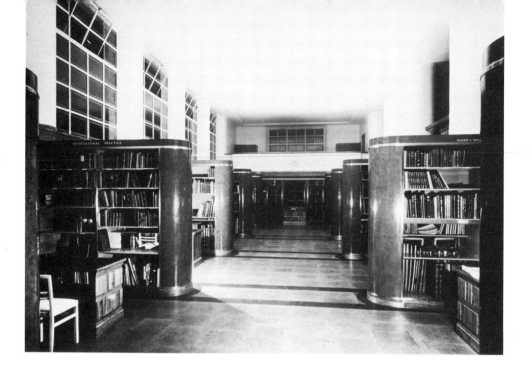

45
Contemporary photograph of
the nave of the Reference Section
of the Library at night, 1934.

Reilly commented on the clean,
colourful surfaces, saying that the
only untidy things were the old
books – 'Some day, I hope, they
will all be given shiny linen covers
to go with the fine clean surfaces
of the metal book-cases'.

furnished with tables and chairs. The rounded ends of the cases
conceal insulated radiators and indirect lighting units, although
additional new lighting was added to the tops of the bookcases in
1982 (Figs. 45, 46). The floors throughout are in cork slabs in two
shades of brown, and the small amount of joinery is of Indian silver
graywood, the tables being in the same wood with blue linoleum
tops to match the colour of the book-cases. The chairs are of
natural English beech upholstered in leather, and both chairs and
tables have not been replaced since 1934 (Fig. 47). The rug hanging
on the wall facing the entrance was designed for the RIBA by
Ronald Grierson and was originally in the ladies waiting room in
the basement.

The Library's title now reflects its status as the national collection,
and it is still the finest and most comprehensive of its kind in the
world. It has 130,000 books and 1,200 periodical titles, and each
year receives many thousands of requests for information about
architecture and the environment. It now has its own Manuscript
and Photograph collections and is embarking on a programme of
computerisation. Although it was originally planned to allow for a
40 per cent increase in stock, and even accommodated the
Drawings Collection in the East and West ends of the Periodicals
Gallery (with its volumes of original drawings unbelievably on
open access in the end bays of the Reference section), the library
has naturally expanded rapidly over the last fifty years and cannot
continue much longer without additional space. The Drawings
Collection itself moved first in 1958 to one room in the newly built
68 Portland Place, and later in 1971, to its present premises at

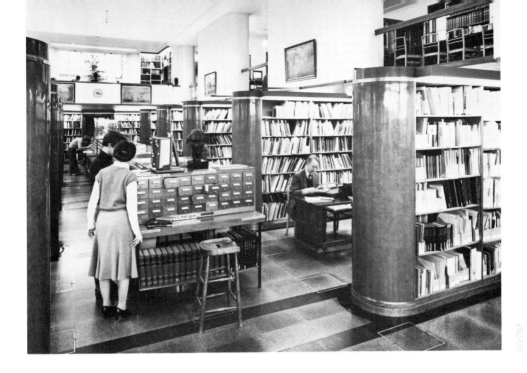

46
The British Architectural Library:
a view of the Sir Banister Fletcher
Reference Section in 1984.

21 Portman Square, which is also the location of the RIBA's Heinz Gallery.

This acute pressure of space has forced the Library to fill the nave of the reference section with card-index cabinets and every available nook and cranny with tables and new equipment, so that it is difficult to recreate the sparseness of the 'laboratory-like apartment' described by Charles Reilly in the *Architectural Review* in December 1934.

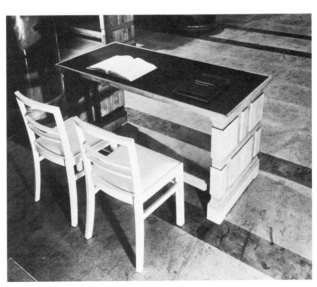

47
Contemporary photograph of a
library table and chair, 1934.

Council room

In 1934 the Council Chamber was the uppermost room in the building, raising its head above the adjoining roof level to obtain clerestory lighting, but masked from the traffic noises of the street. Lined with presidential portraits and with its seating covered in red leather, it is an exercise in the fine craftsmanship of Empire woods (Fig. 48). Different kinds of walnut and maple are contrasted with one another. The two longer sides of the room are covered with flush, veneered panelling of a rare, English, swirl walnut of oyster tint; while the desk-like divisions, which take the form of rusticated walls, and the seat-backs are of English figured walnut of a normal colour. The doors at each end and the pair leading into the Ante-Room are of a darker, Australian walnut with, on one side, English curl walnut panels and, on the other, raised panels of Australian walnut and Canadian maple.

48
A view of the Council room.

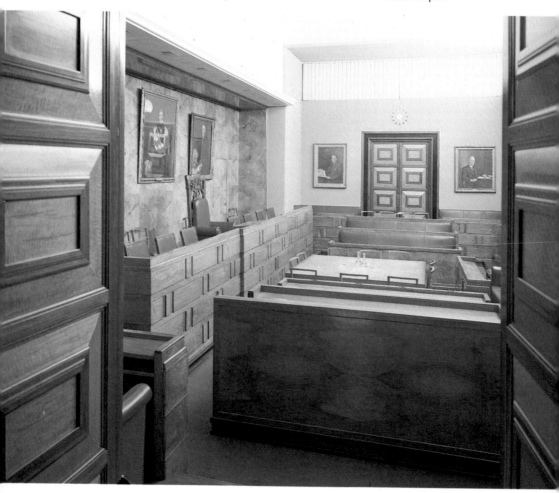

Fourth floor landing

The ceiling of the landing is decorated with plaster relief panels by Morris Wiedman representing, in formal arrangements of figures, various matters connected with the building: 'the ascending lifts' (over the lifts); 'architects in conference' (over the Council Room door); 'study in the library' (over the door leading to the Library Periodicals Gallery); 'the creative force in architecture' (over the South wall); 'building work in progress' (over the East wall and South-East corner) and 'ascending the stairs' (over the staircase).

Also of particular interest and very much the treasure of the RIBA Building are the six acided and sand-blasted glass panels set into the doors opening onto the terrace (Fig. 50). They represent the six great periods of architecture, Greek, Roman (Fig. 49), Chinese, Gothic, Florentine and Modern, and were designed by

49
Detail of the Roman panel.

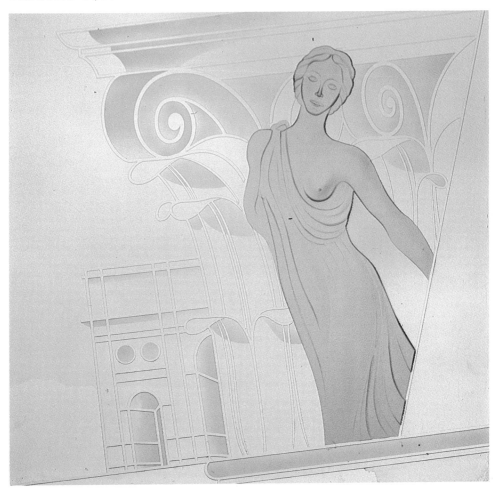

50
Glass doors on the fourth
floor, sand-blasted and etched
by Raymond McGrath. This
photograph was taken from
the terrace roof.

the architect Raymond McGrath and executed by James Clark &
Son. Each period's contribution to building is noted in the panels;
for instance, Greece shows the Golden Section, delineated behind
Athena, which is said to have supplied the proportions of the
Parthenon. With Modern we are given high-rise living in a form
perhaps inspired by Gropius, and the marble bust by Modigliani
now in the Tate Gallery. As the glass faces daylight, the designer
had to be certain of some amount of opacity so the chosen
engraving methods were sand-blasting and brilliant-cutting.
For sculptural effects sand-blasting is ideal since it cuts away the
surface to any depth and width needed, while brilliant-cutting is
best for incised lines which also may be controlled in their depth
and width. By using both methods McGrath achieved the right
monumental effect. The doors were exhibited at the Hayward
Gallery in 1979 at the Thirties exhibition.

Alterations and additions since 1956

In 1948-9, Wornum prepared plans for the rebuilding of 68 Portland Place and for adding two more floors to the main building, and in 1955 was engaged with his partner, Edward Playne, to carry out the work. He retired due to ill health shortly before his death in 1957, and the work was carried on by Edward Playne of Playne and Lacey and completed by 1958. The two new floors are less dominant in profile than those in the competition design and it is hard to believe that they were not part of the original Wornum building. But the addition of 10,000 square feet of space and the increase of activities and administration marked a great change in atmosphere at the RIBA. From the end of 1958 the building ceased to have the private and personal qualities of an architects' club and became instead a busy administrative centre with a staff large enough to fill the new dining room on the sixth floor.

1958-73

In 1958 a design panel was set up to redecorate the building, and Lady Casson was commissioned to furnish the two new floors and to redecorate the Florence Hall, the Reception Room, the Waiting Room (now the bookshop) and the Aston Webb Committee Room. In 1961-2 William Howell and Alison Smithson converted the present South Committee Room into a Members' Room and Bar, in dark purple and white – a scheme that now seems evocative of the early sixties but not of Miriam Wornum. In early 1963 Leonard Manasseh was appointed House Architect, to be succeeded from October 1965 to December 1971 by William G. Apps of Black, Bayes and Gibson, who opened up the Waiting Room by inserting an open glass panel in the Entrance Hall and redid the Members' Room (in brown this time), and from February 1972 until October 1973 by Richard Finch of Richard and Margaret Finch.

1973-6

In 1973 the decision was taken to let out the main rooms to the general public, and consequently a huge amount of work in refurnishing and redecoration was undertaken by the House Committee. Garnett, Cloughley and Blakemore were appointed architects in October 1973 and amongst other changes inserted a revolving door in the Entrance Hall (1974), converted the Waiting Room into the RIBA Bookshop (1974-5), and reorganised the sixth floor dining room into a Bar, Coffee Shop and dining area (1976).

From 1980

In 1980 John Phillips became the 'Surveyor to the Fabric', not 'architect', giving the House Committee the opportunity to appoint different architects for particular schemes within the building. Under his care the marble piers of the Florence Hall were cleaned, the original Miriam Wornum colour scheme returned to the Library and, outstandingly, the exterior of the

building was cleaned and restored to its Neo-Classical austerity, the latter through the generosity of a few members.

The fact that the RIBA Building is administered by a Council and committees of architects (who are often looking for change), makes it remarkable that the alterations since 1956 have been so tactful and self-effacing. The building survived the decade of the sixties unchanged, and this was a time when the styles of the thirties were least appreciated and conservationists were only interested in earlier periods. Let us hope that Wornum's building can survive for another fifty years.

51
The RIBA Bookshop.

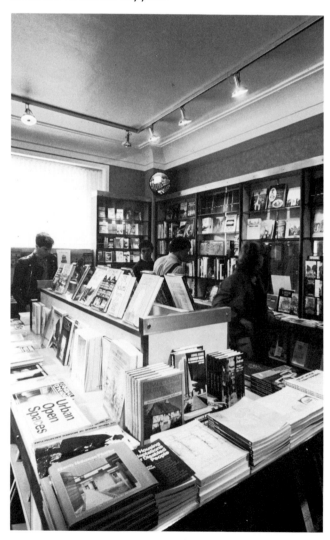

Artists and craftsmen

George Grey Wornum
1888-1957

Architect (Fig. 52). After studying at the Slade School of Art he was articled to his uncle, Ralph Selden Wornum, and attended classes at the Architectural Association, winning the silver medal and travelling studentship for 1909. His first professional work was a studio for H.G. Riviere, designed in 1910.

Wornum served in the Artists' Rifles in the First World War and suffered leg injuries and the loss of his right eye in France in 1916. He then spent two years at the Ministry of Defence before resuming his career in partnership with Philip D. Hepworth in 1919. By 1920 Louis de Soissons was associated with them and, after Hepworth left the firm c1921, de Soissons and Wornum practised from Blue Bell Yard, Westminster until 1930. Their works include: Water garden, Hayling Island, Hampshire, 1920, and several of the Douglas Haig Memorial homes. Wornum's individual works during these years include: reconstruction and decoration of the Palais de Danse, Derby, 1921; King's Hall, Bournemouth, Hampshire, 1922 and St James's Church Hall, Muswell Hill, Hornsey, London, 1924-5.

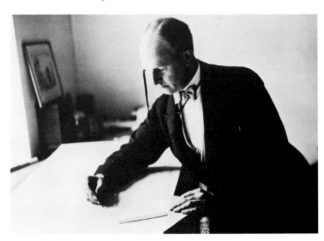

52
George Grey Wornum.
Contemporary photograph,
1934.

From 1930 he practised alone from 39 Devonshire Street, Westminster, collaborating at various times with other architects, and his practice increased considerably after the RIBA Building. His most important jobs were the Clapton Stadium for greyhound racing, Hackney, with A.C. Tripe, 1932; a house at 39 Weymouth Street, Westminster, 1936; the Ladbroke Grove housing estate, N. Kensington, with Maxwell Fry, R. Atkinson and C.H. James, 1936; highways depot for the City of Westminster, Gatliff Road, Westminster, 1936; and the redecoration of the first class accommodation for Cunard Line's 'Queen Elizabeth' begun in 1938 and completed in 1945.

From 1945 to 1955 he was in partnership with Edward Playne, incorporating the practice of Sir Aston Webb. Wornum's health declined in the 1940s as a long-term result of his war injuries and he spent much time abroad in the Bahamas and California. He was elected an Associate in 1910 and Fellow in 1923, President of the Architectural Association in 1930 and was awarded the Royal Gold Medal in 1952. He died in New York on 11 June 1957 while on route to California and was awarded the CBE in the Birthday Honours List published two days after his death.

His American wife, **Miriam Wornum** (née Miriam Alice Gerstle) is a painter and interior designer, and was responsible for much of the colour designing and textiles throughout the RIBA Building. She was born in San Francisco, where she received her first art education, which was continued in New York and Paris. She worked in Grey Wornum's office before their marriage in 1923 and continued to collaborate with him. Miriam Wornum now lives in San Francisco.

Edward Bainbridge Copnall
1903-73

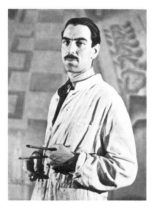

53
Bainbridge Copnall.
Contemporary photograph,
1934.

Sculptor and painter (Fig. 53). Born in Cape Town, South Africa, Copnall came to England as a child and was educated at the Liverpool Institute and Skinners School. He received his art training at Goldsmiths College and the Royal Academy Schools, and left the latter in 1924 to earn a living as a portrait painter. In 1927 he met Eric Kennington, whose work made a deep impression on him, and as a result decided to turn to sculpture. His decorative sculpture and painting for the RIBA Building was therefore an important early commission which increased the range and quantity of his work in the thirties.

He executed wood carvings for the liners 'Queen Mary' and the 'Queen Elizabeth', illustrating the history of shipping, and engraved glass screens for the latter ship and for the Odeon Cinema in Leicester Square. Important London commissions include: one of the four giant figures on the Adelphi façade, 1936-8; the Carrara marble relief panels on St James's House, King Street, 1959 and the Stag in Stag Place, Victoria Street, 1959.

Always an experimenter with materials and new effects he began making figures of fibre glass in the 1950s, and his first figure in this medium was the 'Swan Man' for the ICT building on Putney Bridge. Copnall was headmaster of the Sir John Cass College of Art from 1945 to 1953 and President of the Royal Society of British Sculptors from 1961 to 1966.

James Woodford RA
1893-1976

Sculptor. Born in Nottingham, the son of Samuel Woodford the lace designer, Woodford trained at Nottingham School of Art and, after service with the 11th Sherwood Foresters throughout the First World War, continued his studies at the Royal College of Art and was awarded the Prix de Rome for Sculpture in 1922.

His work for the RIBA Building from 1932-4 – the bronze doors, stone pylon figures and relief plaster ceiling panels – was his first commission of real importance, but his creation of the ten, six feet high, 'Queen's Beasts' for Westminster Abbey at the Coronation in 1953 brought him international recognition as an heraldic sculptor.

Other works include: decorations for the first-class smoking room of the liner 'Queen Mary', the Memorial fountain in BMA House, Tavistock Square, panels for St John's Wood Barracks, groups at the Ministry of Agriculture, Whitehall, the Robin Hood bronzes at Nottingham, the bronze doors and fountain for Norwich and scores of major works for public buildings in Great Britain and abroad. He was elected Royal Academician in 1945.

Jan Juta
b. 1897

Glass engraver, portrait painter, illustrator and mural painter. Born in Cape Town, South Africa, he was educated in South Africa and at Christ Church, Oxford, the Slade, the British School at Rome, in Madrid and with Maurice Denis and André Lhote in Paris. He became interested in glass through trying it as a medium of decoration for the architects with whom he worked in America, and his commission for the RIBA Building was his first in England.

His glass work in England has now mostly disappeared, but it included two large staircase windows illustrating flying for the Bristol Aeroplane Company offices in 1935, which were bombed in the war, and work for the two Cunard liners, RMS 'Queen Mary' and 'Queen Elizabeth'. For the former he designed a large silvered and brilliant-cut mirror for the ballroom, and several smaller features. He also illustrated *Sea and Sardinia* for D.H. Lawrence and painted the portrait of the writer now in the National Portrait Gallery.

In 1939 Juta left England and settled in New York where he continued as a specialist in decorative glass; later he turned to mural painting and became President of the American Society for Mural Artists.

Raymond McGrath
1903-77

Architect and designer. From 1921-5 McGrath studied at the School of Architecture at Sydney University and in 1926 moved to Europe. From 1927-30 he was a research student at Cambridge University.

His first independent work was the remodelling of a private house, Finella, in Cambridge for Mansfield Forbes who was fascinated by the potentialities of modern materials: here McGrath experimented with engraved glass, coloured glass and mirrors and subsequently became a specialist in this particular field, publishing the classic work on glass *Glass in Architecture and Decoration* in 1937.

In 1930 he set up in practice in London and was appointed head of a team of designers for the interiors of Broadcasting House, 1930-2. His expertise as a glass designer led to the commission to design the glass doors on the fourth floor of the RIBA Building in 1933. In 1940 McGrath moved to Ireland as Architect to the Office of Public Works (Principal Architect from 1948-68).

Other artists and craftsmen who worked on the RIBA Building were:
Denis Cheyne Dunlop, sculptor, who designed the pine 'Dominion' screen in the Florence Hall;
Ernest George Gillick ARA (d. 1951), sculptor, who designed and cut the RIBA badge and inscription on the Foundation Stone;
Nicholas Harris, painter, assistant to Bainbridge Copnall;
Percy Smith (d. 1948), draughtsman and etcher, leading practitioner in lettering and book designing, who designed the lettering for the Royal Gold Medallists and Past-Presidents in the entrance hall;
Morris Wiedman (b. 1912), sculptor, assistant to Bainbridge Copnall, who executed the ceiling panels on the fourth floor, and
Seaton White, who modelled the bronze lions on the exterior balcony and on the first floor sliding doors.

Selected bibliography and Acknowledgements

Bibliography

RIBA Archives
Premises Committee Minutes, 1923-30;
New Premises Committee Minutes, 1930-1, 1932-7;
New Premises Fund Account, 1934-9.

E. Maxwell Fry
'The Designs Discussed',
Architects' Journal, LXXV, 4 May 1932, pp.608-9.

H. S. Goodhart-Rendel
'Architectural Tendencies. A Retrospective Review of the RIBA Competition',
Architect and Building News, 24 June 1932, pp.417-20.

G. Grey Wornum.
Builder, 9 December 1932,
Wornum's description of his revised design.

A. Trystan Edwards
'The RIBA building. An appreciation of the Exterior',
Architects' Journal, 8 November 1934, p.669.

RIBA Journal, November 1934.
Complete issue on the RIBA Building.

Architectural Review, LXXVI, December 1934.
Complete issue on the RIBA Building.

Margaret Richardson
'The RIBA Building' in 'Britain in the Thirties' (edited by Gavin Stamp),
Architectural Design, Vol. 49, No. 10-11, 1979, pp.60-71.

Roger Pinkham
'Architectural and Decorative Glass',
Connoisseur, CCI, 1979, pp.244-51.

Acknowledgements

I would like to thank Robert Elwall, Angela Mace, who has brought order to the RIBA Archives, Gavin Stamp and Jan van der Wateren.
Margaret Richardson

Photographic credits

André Goulancourt
Figures 23, 24, 25, 26, 27, 29, 31, 32, 33, 35, 36, 39, 40, 43, 46, 48, 49,
Four cover photographs

Geremy Butler
Figures 1, 2, 7 to 18, 42, 50, 51 (RIBA Library);
Figures 19, 20, 21, 22, 28, 30, 37, 38, 41, 45, 47, 52, 53 (RIBA Photograph Collection);
Figures 3, 4, 5, 6, 44 (RIBA Drawings Collection).

WITHDRAWN-UNL